ode

to

fragile

Shabnam Piryaei

Plain View Press
P.O. 42255
Austin, TX 78704

plainviewpress.net
sb@plainviewpress.net
512-441-2452

ISBN: 978-1-935514-75-6
Library of Congress Number: 2010934719

Cover art by Pelin Kirca.

Acknowledgements

"Beit Hanoun" originally appeared in *Runes: A Review of Poetry*; "to enunciate the fertility of a pause", "Alejandra" and "disarmed" originally appeared in *The Florida Review*; "partition" originally appeared in *The Furnace Review*.

Contents

And if it is a fear you would dispel,
the seat of that fear is in your heart
and not in the hand of the feared.

Khalil Gibran

I

to enunciate the fertility of a pause

I.

your stopped hand
wills another crease
in the passage from water
to word

a pause is never empty
waiting to be filled

it is a parting from ourselves
with a sound so quiet
the hour leans in
to listen

tenderness
is a rhythm measured
by its rests

II.

in the space between two words
One woman retreats back from
the precipice of a windowpane
Another advances
and empties herself into the skyline

beit hanoun

outside your window
where dogs circumscribe with urine
their places
lies a pool of your daughter's blood.
visceral mornings
sing deep throat songs,
and you can't stop
the sun from lighting shards
like rubies.
and you can't stop her voice
from taking your sleep
like a feast.

outside your window
where night chased itself
blindfolded, through the dirt
lies a pool of your daughter's blood.
someone must bring a broom,
or a towel, or a bucket
of water
someone must wash away her blush
for other children's feet
for life to move forward.

misery
is the empty-handed departure
from a dream.

a neighbor whispers too loudly
at least a skeleton
is something
to hold

your son
suddenly old
inspects the sole of every shoe

terrified
for the task of protecting
what remains.

they say hope
will return and when she does
greet her warmly invite her in.

last night you soared
above mountains
of the small pink shoes
she would have worn
to your sister's wedding.
you discovered a man pressing
his nose against a window
to stop up the blood
another fumbling breaking his fingers
under boots to find his cracked glasses
trampled
in the traffic of apathetic passersby.

I do not want to wait for hope
says your wife.
She is a traitor.

you stand motionless in the shower
turning cold
convinced of the phantoms trapped
in the fan
listening intently for the last
laugh you did not memorize
in time.

wondering should you run
to your son and seize his face
between your hands

howling *I love you*
we, we are still here
or instead
withdraw, disappearing
like the train of a dress around a corner
because you have heard
or you have learned
the greater the love the deeper the loss.

outside your window
where months from today
an old man will kneel
to pick up a small white stone
and shiver
understanding too quickly
why children's teeth appear in alleys
lies a pool of your daughter's blood.
someone must bring a broom,
or a towel, or a bucket
of water
someone must wash away her blush
for other children's feet
for life to move forward.

Alejandra

you left behind
your eyes like a satellite.
but took
away both hands,
knowing flesh concedes.

I hunt a wild text removed
from the line

that you fit delicately
in the language of walls
inventing slow violets
from their potential of rubble.

your memory
open-legged on a stool carves
our hearts from a slow, resistant water.

I would tear into Seconal's petrified
throat for the last nascent word in
its bed of lilies
if it is a boat
for just one feeling.

disarmed

the rain exorcises
spirits from the dirt.

wet and wandering they knock
about the streets.
I adjust my heart to
their tenderness
like eyes to the dark.

I am forgetting
how to give.

perhaps I am one of them
in need
of one word with an ivy-covered window,
of one seasonless hand
cupped selflessly to my face.

of a song
sung by a cross-legged girl
with blossoms in her throat,
a song that doesn't carry me,
weeping like a Sunday, to my bed.

disentanglement

despite an infrastructure of concealed rituals
they appear
bats springing out of porcelain bells

two hands
are as vulnerable
as what they wish to save

struck

somewhere
moon milk ribbons
river skin.

between departure and absence,
life thrusts an ephemeral blossom,
the body remembers
even after the heart lies down flat.
the soles of her feet
upturned and misplaced
recall the wet curved stones
walkway into the clear, blind heart
that can only enfold
hold pass by
all at once.

the last word
was almost ready
to be born
but he smashed the egg
inside her lip
a drop of blood
emerged, gills wrapped suddenly in air,
glistening then frantic,
and the small spread
between mouth and cold kitchen tile.
the footprints on the back of her blouse.
the flour like dust
of an annihilated moment,
the clock unsure of what to measure.

and oh,
the idiot dough
is still rising
waiting to be bread.

recovering instinct

how easily a hammer descends
on a bag full of pregnant spiders,
how monotonously one can read
the instructions to tying a noose

there is a neck, waiting
with its history of kisses,
and whispers, and sunlight

remember, remember

she extracts
gold filaments and sinew
to weave her song
against the unrelenting silence
of a steel room

how fertile are the flaws
of one voice

I am still a stranger at the threshold
of the glacier's blue promise,
two twigs dancing sensuously in the dark,
and the steadiness of a note
running effortlessly across a canyon
shooting arrows out through its skin

what a sad, and unfinished garden

what a multitude of positions
that cast easily forgotten shadows

she is building
from discarded, quiet things

a fresh vein for housing sudden rivers,
what boldness to drown these sterile masks
and float them, face down
shuddering from their cargo of hope

song arriving

notes bleeding from their feet
build a bed in the dark

in every pause
guilt overripe fruit
stains the shadow it casts
in me

in every repose
where depopulated eyes drop
from an agonized tree
 an Evin prisoner plasters his
 heart to his cage

walls that cannot sway
nor sleep nor
speak
watch a woman devour herself
with no teeth
only the small rusted spoon
of her daughter's first meal

interrogation

I.

He stirs his coffee
as if he cannot smell
her baskets of blood
her nose annihilated
a beak born in a stampede
the final syllable of the snail's shell.

Have a seat he says
without lifting his eyes
as if this were an interview
for a position in his company
as if she had strolled in alone.

As if he could not hear
the screams entirely permeable
to grimacing erections.

Would you like some coffee?
he asks as if her wrists were not smashed
together with wire, lying lady-like
in her lap.
As if dangling teeth could endure
the parting of lips.

Staring into the eye
not swollen shut he says
I am sorry for your loss.
I am sorry for your loss.
But the tidal wave of boots ascended
from his head
a gesture innocent
as a small wooden boat rocking
just once.

It was a girl
a prisoner had told her.
Believe me. It is for the best.
This is no place for a woman.

And she had loathed advice
wrested from the impossibility
of stone cells.
But now.

Witness to appetite.
Grabbed from the inside
like a suitcase
and dragged
until death reigns as the only freedom,
a chant repeated
through the fog.

II.

a fist is a cheap, deadly weapon.
some doorways we discover
only after their collapse.

they took my daughter
before I knew her.
the remaining cold brick
swings to no lullaby.
I have tried.

he stirs his coffee calmly
watching sugar crystals sink
elegant and unresisting.

my body is cheap
they say to me
grunting like starving pigs.

they took my daughter
and hammered a path through my neck
for the wind to explore.
winter found a sullen playground
in the hollow passages
where blood used to make meaning.

III.

there was a world
hatched in a song
I have seen the music paper in my dreams
each note the same fist-shaped heart
parting from its core like a moan.

a man shrieks
where are my legs
give me back my fucking legs
an innocuous boat catches
a single current
a soldier disappears
silence returns armed
and with her face rubbed
entirely away.

I had a husband once.
his voice opened my name
like a fig
only to show me its treasures.

they made me watch
his paper feet
disband in the rain.

a kiss in the dark

a man peels his skin
off in a busy square.
the children are squealing, the fountain
will not stop building its elegant body
of water,
a golden dialogue with the luscious
groan of the sun.

before night parts
smoothly her legs,
a steel mallet collides
with a deer's skull,
a boy squeezes his heart purple
waiting at the cusp of collapse
for his next
embrace.

I hear the foam spreading and gathering
its body at the shore
despite me.
silly tendrils, like faint curls
atop the head of a schizophrenic lover,

and the crane raising twenty nine
human bodies into the air
a carnival ride fitted for your soft neck,
higher than you've ever been,
look,
you can see your house from here.

the prayers that crawl
like a hatched nest of spiders,
riddled with the responsibility
of fear,
are born withering.

look.
the things at hand
thrust soft tumors
in their wait.

parting our chests with fingertips

I.

his hand is there
on the tender spot
of every calloused moment

to build the boat is not enough
you must row it
to where the mountains devour the sun

the lesson is simple:
petals, though armorless,
thrust out for a single graze
of the sun's slow breasts

the human voice
can undress any lullaby
when the heart emerges
glistening

II.

somewhere a child
cradles a bird with a broken neck
unafraid
of this waiting wall of eyes

her whispered melodies
harbor wind enough
to strip us bare

patience now
as the dew gathers its body

and gruesome
crafted shadows
hover and land
like singed wings, or regrets
a weary routine still within reach of a nerve

night is unmerciful in its glare
through our tenuous armor
in the cold mouth
something green and trembling with seeds
knows your name

lean into its terrible mirrors
that hold captive all that you have loved

every hollow repeated escape
wilts
the heart you so carefully unfold

a whole life can be passed
beginning

I have watched
the entire pilgrimage of light
dissolve in a wailing feast
but fled
quaking
from my own steady gaze

for one hundred years
one can linger
clutching paper dolls and dagger tips
counting numbly the useless markings
of a doorway

for one hundred years
one can witness the snow melting in one's hands
waiting to believe in one's own sculptures

III.

there is this:
in every moment
a veined tunnel,
a gasping blossom
bursting suddenly from a stone

partition

between us
distance births chills
one after the other
tremulous chains
bondage for a lamenting ghost.
we speak over her body
phrases that don't meet
the wrong ends brushing and repelling
like unfortunate magnets.
yes
deep down
the foundation is stable.
far far down
there is a cavern, a river, a beating heart.

the sound of water into water.
the hour smiling off the clock.

it is utterly winter.
like ink in the water tank.
the woman struggling to untie the ropes.
the audience watching without moving.

I have concluded that eggshells
are a terrible trick.
such flimsy armor.
such a generous break.
a modest, but potent spill.

the chills are now dead,
lie coiled
in a mound on the floor.
distance lies sprawled and snoring beside them.
we pretend not to wait.
but waiting has a sound,
a stone swelling where the breathing should be.

four o'clock

cold hands cold feet
cold hands cold feet
cold hands cold feet
cold hands cold feet

 four o'clock.
eternity begins at four o'clock.
the white sheets stop at the ankles.
blue toes like obstacles
like unhinged jaws swallowing
remaining movements.
at four o'clock
a monstrous fist
falls from the sky
on a treasured egg.
a small bird can't stop flying
into walls and parked cars.
I want to enact saviors
but I can't control my quaking.
I don't want to shake
the swallow to death.
they pile exposed heels
and anklebones, elbows, breasts, stomachs, teeth, flowing hair,
tangled throats silenced too suddenly midshriek
in a truck
and the paperwork walks
like an old man underwater
and tomatoes rot in the sun.
it is July. the sun is an umbrella
obstructing the wind.
I kick pebbles along
the formality of scalding sidewalk,
forgetting
whole families

pile unevenly
and all at once
like potatoes
to the grave.

inventory of a july

the hour, shaped like a brick house,
has a painted doorway.

the heat unapologetically
contemplates on our faces,
no long-awaited envelopes open themselves in my lap
no cool rain gathers like a crown.

someone has just discovered a tiny
familiar hand in the rubble,
and a dandelion is left infertile
by a blind boot.

in a room
between two people
the head of a lie emerges
through the membrane of a moment,
slime-ridden, toothless,
and grinning.

I imagine the wind pulling at our bodies
the way the ocean pulls at our feet with her fingertips
trying to draw us in
past the luminous surface
into the coldest, darkest parts,
an intimate and necessary offering
that hovers over every scrambling escape.

paper confessions

I.

regret and guilt follow me
as if I were their mother
stroking with the dissolved edges of a punished whisper my arms,
singing to themselves
lullabies made of dead bees
as if each does not know the other exists.

at night
I hear their muffled lovemakings
through the futile wall
as permeable as a humiliated smile.

listen
we devour forgiveness each time we call out her name.
I follow my decaying footprints to her door
but only an eyelid remains.

and you
know the secrets of unstartled clouds
that form serene processions in the filthiest puddles,
you hear the exhale of every grape you peel,
and the exhale of a woman dissolving into fog
to make touch inevitable.
I am still learning to evade the sabotage
greeting me with a nod every morning, the same sabotage
I am addicted to.

listen
they moan and weep into each other's necks
and tomorrow they will pretend again to be strangers.

of what use are these paper confessions
but for one ill-fitting paper dress.

somewhere a woman unfastens her daughter's noose
after the crowd has gone home to their own children.
somewhere a glass moment discovers its own power,
and thrusts itself to the ground.

apologies repeat themselves inert.
I have to pin up their corpses to remember my intentions.
I must remember to speak when it is time to speak.

II.

who knew anvils could hang
from small, soft heads.

on a kitchen table
a balding rose coughs
just once.
another velvet petal
unclasps.
the disappearing woman in the hospital bed
no longer seeks refuge in her wet heart.

and the boulder
watching sparrows drop echoless
at its feet,
is unable to reach out, to save
a single soft, feathered body.

path in the wood

navigating volumes
in the physical silence of written words
and suddenly
you tilt your head slightly
to the left
cupping the song and instrument closer
and in the repose of where
the fruit ripens and grows heavy
in the briefness between note and note
a new mountain tears upward
into being
somewhere in the middle of a plane

even the slowest movement
has a sound that can be heard
if you press your hearing lustfully, carefully
against its speed

II

*Men pity and love each other more deeply
than they permit themselves to know.*

Tennessee Williams

dollhouse

gossamer dressed in droplets
condemned
to the fantasy of a gray canvas

the fetus will be crushed
under the weight of the sky

how carefully they brush together
their cheeks
to hear the sound of their skin

please,
anything
to cast a shadow
a gentle, weightless blanket
over these scorched and silent things

<darkness. gunshots, and voices that yell and scream in a language we can't
understand. suddenly, the sound of an explosion, then a prolonged silence.
lights go up. a landscape of injured plastic baby dolls. hundreds of thousands
of them, with missing eyes, tangled hair, naked. nothing in the distance but
sky, no mountains, no trees, no houses, no birds, no people.
slowly some of the dolls begin to move and a young girl climbs out from
under a layer of mutilated plastic babies.
she is disoriented, confused, terribly afraid.>

girl: momma? <looks about her frantically; sees nothing but miles and
miles of ruined dolls. desperately:> momma? momma? <begins to fish
through the sea of dolls, flinging plastic heads and limbs, her voice rising to a
scream.> momma? momma?

<a song begins in the distance. a violin and a trumpet are confessing to one another. at first slow, cautious, they draw back and suspend moments in mid-air, like pendulums, before releasing. as the song progresses their movements grow more frantic, and fierce, until they are entering one another, penetrating and searching more deeply with each stroke.
the girl is screaming something in a language we can't understand.
everything she passionately and desperately thrusts disappears into an unacknowledging landscape. the search and the song never end.>

running with the last heart in your hands

the way bone crumbles
no matter how white
or surrounded.
the way the eye clutches the branch
waiting for the bird to be born.

catch the house of cards
before it falls flat,
while you can still imagine
families inside.

<two men sitting on a bench facing the audience. birds call to one another
from branches. for a few moments, neither man speaks.>

A: <turning to B> So what did you do?

B: <still staring out> When?

A: When he *hit* her. What did you do?

B: What are you talking about?

A: Come on man. Stop playing around.

B: I have no idea what you're talking about.

A: You have no idea what I'm talking about? You just said he hit her.
So what did you *do*?

B: Maybe you're mixing me up with someone else.

A: <sarcastically> Oh yeah, yeah, my mistake. It must have been another guy with the same ugly-ass glasses, with one leg crossed over the other, sitting right next to me on this bench. You're being ridiculous right now.
<turns toward the audience. a long silence.>

B: <still staring out> I killed him.

<pause>

With my bare hands. And he pleaded, and he pissed on himself, and I just kept at it. I kept repeating, how does it feel? How does it feel? And he started to apologize. For hitting her. So then I started apologizing. I asked him, does my apology make it feel any better?

<long pause>

<turns to A> But you want to hear something crazy? Something inside me started to feel bad for him…I couldn't shake this feeling, like he was so pitiful…so…lonely, almost. But I just kept on beating him, like there were two of me. One of me was real furious, and kept seeing him pounding on her, you know, kept imagining her begging, her falling all over the place…
Then the other me…I don't know…I saw him as a cute little kid, you know? The kind that smile at strangers on the street, and call out for help in the middle of the night when they've had bad dreams…
What had to happen to him to make him that way? I mean, think of any baby you've ever seen. Does it ever cross your mind they can become killers or abusive or something? Of course not. All you think of is kootchy-kootchy koo, then you go on with your miserable, polluted day…<looks back out over audience> Something's got to happen, something smiling has got to break, to make a soft, innocent baby turn into a guy like that, so sharp and empty at the same time. With so much darkness inside.

slow dance

smooth round stones crowd your pockets
crouching, you pile them
carefully, the beginning of a ladder

you repeat
strawberries bare wildly
for us
their hearts

resting on the carpet,
thin sugar globes
construct for you diaphanous smiles
despite their fate

<A man and a woman in a bedroom. The woman is wearing only a
lavender satin slip, and her dark hair is gathered up in a bun at the top of her
head. The low light accentuates her bare collarbone and the smooth lines
of her long neck. She faces the man, standing close to him, her toes nearly
touching the tips of his sneakers. The man is fully dressed, wearing a t-shirt,
jeans, and shoes. The expression on his face is one of complete exhaustion.
As if long ago he had begun to withdraw, and now, entirely absent, he is
merely going through the motions of living. We can't help but feel that we
have arrived too late in his life, too late in the story to be able to change it.

The woman takes the man's hand into both her own. Her two hands
combined are nearly the same size as the man's palm. She is staring directly
into his face. It is hard to tell where the man is looking. Although his face
is turned toward her, it seems he is looking at nothing at all. She pauses,
closes her eyes, then opens them again, casting her gaze directly into his eyes.
She is still holding up his hand, paused in mid-air between them. Slowly
she draws his hand to her body and cups it around her breast. She does not
release his hand, but instead, closes her eyes and holds it there, pressing it
against her, feeling herself through him. The man does not resist, nor does

he respond. He is like an unthreatening zombie, like a melancholy puppet, lacking the fire that drives urgency to the surface of the woman's every gesture.>

Woman: <still pressing his hand to her breast> Dance with me.

Man: I don't really want to dance.

<The woman, pretending not to hear him, walks away for a moment. Suddenly, an achingly slow song fills the room, revealing this as a step in a previously planned effort.
She returns to him and takes his arm, placing it around her waist, resting it on the curve of her lower back. He does not resist. She begins to kiss his throat, moving her waist as smooth as honey, like a liquid clock, around and around and side to side, pressing closer and closer against him. She takes his other arm, and wraps it around her other hip. He shuffles his feet dispassionately, his eyes still gazing on the same nothing as before. His resistance, like his involvement, is weak and un-invested. They move together in a gradual circle, the man dragging his feet, the woman guiding him, pressing her face into his chest, gliding her hands up and down under his shirt. The curves of her body form sensuously shifting shadows in her satin dress.
The phone rings. The woman continues dancing with the man. It rings again. The man withdraws his arms, stops shuffling his feet.>

Man: <Unconvincingly:> I should get that.

<He turns and leaves the room. The woman's hands retreat to her sides. The music is still pouring out from its wound. The woman, suddenly very cold, wraps her arms around herself. The objects in the room pretend not to watch. Outside, children are playing. Occasionally a scream can be heard penetrating through the window and the music. The woman does not move, but her fingernails push silently and deeply into her bare arms.>

procession

how blessed this barren landscape
free from tender
and torturous associations

free to break
open and be still

to turn away its head
its mouth slightly ajar
absorbing none
of the movements
of the clouds

*<a line of soldiers marches through the dull, nocturnal snow. their legs rise
and fall in sullen synchrony. they are in hope's cemetery, but they cannot see
the markers hidden beneath the snow. as they march, a band plays a familiar
children's song, but pauses for four counts between each note. in every
pause a soldier falls quietly onto his back, and the others march on. when
the last soldier collapses, the band stops playing. we hear the same song as
before but now through a single music box, in regular time. as the music box
plays, the throats of the soldiers part and from each a swallow emerges and
flies into the now-dawning sky.
as the music fades, the lights go down.>*

<pause>

<we hear the voice of a very young boy through the darkness.>

young boy: Daddy? What was the war like?

yeki bood, yeki nabood

fairy tale sails ships on her tresses.
from her hands spring talking woods.

at the end
the wounds will have healed
scarless

and she will sew a dress of lilies
for the smiling bride.

Careful with this one. She looks like my daughter. <*He appears nauseous. He can't take his eyes off of the girl's face.*> Dig her a separate grave. <*Not hearing a response, he looks up.*> Are you alright? Hey, you're gonna have to get used to this, they do this kind of shit all the time and we gotta cover it up.

<*pause*>

Look, give me your shovel. Go take a short walk or something. Just don't be gone too long. I gotta get up early. I got another job in the morning.

<*The other man speaks.*>

Alright, alright. Don't apologize. You'll get used to it. Go now, so we can get this done more quickly.

<*The other man speaks.*>

With her? Give her to me. <*He gently takes young girl's body and places her down, carefully, on the grass. He looks around for something, finds a rag, rolls it up, and tucks it under her head. He takes out a box of cigarettes, pulls one out, and stuffs the carton back into his pocket. He turns to the girl.*> You can sleep out here a little while longer. It's

nice tonight. The moon looks like an electric egg. Enjoy it, listen to its stories and remember them for...for when...<He abruptly puts the cigarette to his mouth and lights it. He smokes the cigarette slowly and in silence. He occasionally checks his watch.>

<to himself: > Poor guy. He was shaking like he'd just blown a guy's head off or something.

<The other man returns. The man who was smoking puts out his cigarette and drops it into his shirt pocket, to smoke later, while waiting for the bus that will take him home.>

Alright. Let's finish this. <not looking up at the man:> You look better. <He hands him back his shovel.> Dig her a separate one. I'll deal with the ones that are left.

love song

he rises from the east
and my heart oh, how
he speaks its name
this electric murmur
quiet
through the still pool of morning

<Dolly, on the porch, sipping beer. It is night. High in the sky there is a bright white moon. In Dolly's bedroom, under her bed, there is a rifle. It has been there for years. She never forgets that it is there.
The dog is asleep beside the rocking chair. Dolly is rocking slowly.>

Dolly: I loved him. I loved him *crazy*. I could have died right then, happy as a clam. He had a shadow as big as the state of Montana. He was a *man*. *<She says the word "man" in a much lower, thicker voice, then chuckles to herself.>*

<The dog is still asleep. Dolly takes a sip of beer. A girl of about fourteen opens the screen door.>

Girl: Ma. Where are the pills? My cramps are killing me.

<Dolly doesn't respond.>

Girl: Where are the pills?

Dolly: Why are you still up?

Girl: I can't sleep. Where are the pills?

Dolly: In my purse.

<Girl, about to close the screen door, stops, sticks her head back out.>

Girl: *<irritated>* Are you drunk?

Dolly: Go to bed.

Girl: Ma, I'm serious. How many beers have you had?

Dolly: Can you please leave me alone? I'm not operating any heavy God-damn machinery. Take a pill and go to bed.

Girl: Fine, but please stop talking to yourself. It's embarrassing. <Leaves.>

<Dolly chugs the end of her beer. She puts down the can, then grabs another one from a cooler beside her.>

Dolly: He used to breathe into my ear, gave me the goosebumps every time.

<She opens the beer, takes a long drink. The dog does not respond.>

soon

teddy bears lay like lily-pads
or casualties of war
hushed along the skin of rivers far,
far from here

this ceiling of cloud suffocates
on the rain it won't release,
the prayers it swallows greedily
in their trajectories toward the stars

my baby brother laughs
like a family of pearls
coming up for air,
like two hearts writing
a song

I promised him, we will build
a house in the trees,
he will protect the eggs
balanced on the branches

and the moon,
despite her amputated fingers,
will stroke our hair
singing in my mother's voice

<A young girl, about twelve or thirteen years old, walks into a large, empty hall, in what is perhaps an old, abandoned palace. Inside, there are nothing but enormous marble pillars. The space is dark and dusty, and her footsteps echo as she walks. She clings to a small bundle, holding it close to her chest. She stops near the center of the room.>

Girl: <Cautiously.> Hello? <Her voice resonates hollowly. More loudly.> Hello? <Echo. Then silence.>

<Girl relaxes slightly. She has bags under her eyes and her face appears older than her age. She pulls a sleeping bag out of her bundle.
She shakes it out once, and lays it flat on the ground. She removes her shoes, then her socks, and sits down. With both hands, she rubs each foot, one at a time, grimacing in pain. When she is finished, she brings her knees in toward her, and drops her head into her arms. Her movements are slow and marked by exhaustion. She squeezes the flesh of her arms tightly with her fingers. Silence. After a moment, she raises her head, turns, unzips the sleeping bag, crawls inside and zips it back up. She closes her eyes and falls asleep.
A moment later, Fear steps out from behind a pillar, though still standing close to it. He is trembling violently, and to his eyes and skin cling centuries of sleeplessness.
A few moments pass, then Dream walks in, carrying an enormous set of feather wings and a bag full of framed photographs. In one hand, she holds a rope, and as she advances we see that she is pulling behind her two horses.>

Dream: <Suddenly disheartened.> Oh no...What are you doing here?

<Fear continues trembling.>

<Dream stands there, her shoulders slumped. She turns, and walks slowly back offstage, leading the horses off behind her. When she returns, she is empty handed. Dream looks over at the girl.>

Dream: Poor girl. <Sighs.>

<Dream begins undressing. Fear does the same, still shaking uncontrollably. When they are completely nude, they advance toward one other and the lights go down.>

kinetoscope

<the stage is split in half with a partition. stage right, at a wooden dining
table, a mother and father sit across from one another, their teenage daughter
between them, facing the audience. the lights are up only on their side of the
stage. stage left is completely dark. the family eats without speaking, and
for a while we only hear the sound of utensils against dishes. no one looks up
from their plate.>

against a silence teeming with words
interlocked hearts
can grind themselves to pieces

repeatedly guilt
makes love to imaginary stars
birthing endless constellations
that writhe on the living room floor

<lights go up on the other side of the stage. stage right, the family continues
eating, but we can no longer hear them. stage left there is a door. a young
girl, seven or eight years old, walks in wearing a backpack. she closes
the door behind her and drops her backpack on the floor. she goes to a
refrigerator that is placed against the partition. she opens the door and looks
inside so that the door covers her whole body. she stays this way for a few
moments then re-emerges empty-handed, closing the refrigerator door. she
turns, takes a few steps, and lies flat on her back in the middle of the floor.
after a few moments she rises and goes to turn on a radio.
Brahms' Hungarian Dance No. 5 begins to play. she immediately begins to
do an impassioned and awkward version of the Cossack dance, crossing her
arms and going down and up, all the while with a broad grin across her face.
when the song ends, she stops dancing, walks over to the radio, and turns it
off. she lies down again, on her back, on the floor, and the lights dim over
her. our attention returns to the family. the tense sound of utensils against
dishes can be heard again, emphasizing the otherwise silent scene. the father
rises suddenly from the table and exits.
a long, heavy pause. the daughter turns to her mother:>

D: I'm sorry.

M: What? Why are *you* sorry?

D: I should have thought before I spoke.

M: <*exhausted, her skull hurting. not able to surmount the pain enough this time to smile.*> Honey...<*trying to gather energy, but failing. trying to be tender.*> What are you talking about? This has nothing to do with you.

D: No, it does. I should have thought ahead. If I hadn't mentioned that stupid television show, then the laundry would never have come up, and then this whole argument never would have happened.

M: <*with more control now, getting up to clear away the dishes, pretending as best she can to make little of the evening.*> Do you even hear what you're saying? It sounds like a riddle. These tensions run deep honey, you know that. They'll push their way up whether we want them to or not. And they have nothing to do with what you saw on television.

<*pause*>

<*tenderly*> Please. Don't spend so much time policing your thoughts. <*trying to sound light and playful again.*> Come on. Let's clean up and go to bed. You have school tomorrow and I have to get up early for work.

<*they gather the dishes and exit stage right. lights go up stage left. the young girl, still on the floor, stretches and sits up. she had fallen asleep and now finds the room, and the day, disappointingly, exactly the same as before. she rises and approaches the radio. she turns it on and we hear Brahms' Hungarian Dance again. she does not smile this time but begins twirling around and around with her arms outstretched. she begins slowly, and increases speed like a small dervish. she spins faster and faster, wandering, for lack of balance, all across her side of the stage until it seems she will collapse. the lights go down.*>

waking up here

two ropes can twist
too tautly to remember
how to synchronously sway
in a breeze

what a chilling autumn
these fallen, cupped palms
soft, and soft
and countless stampedes
crushing them
whisper by whisper,
this chemistry of breaking
heroes

there is a flesh baby
floating in a cut-
out basket
past the paper houses
the origami lovers
toward the rain

W: *<trembling, with one hand on the sofa>* How, Michael, *how* are we
going to make money? *How* are we going to survive with a baby?

M: *<looking down, like a child>* I'm an artist, I'll just make more---

W: *<furious, tears swelling in her eyes>* You are *not* an artist! You twist
roses out of colored paper on a trashy table in the park!

*<Michael begins twitching. He is wearing an old dirty suit. The plastic
folding table leans against the closet door.>*

<W gets close to Michael's face.>
Tell me Michael, when was the last time you sold a rose? Huh? When was the last time you made a *dime* for us? *<She searches his face in disgust.>*

Michael, no. *<She walks away, shaking her head.>* No, no, no, no, no. No more. *<Suddenly she turns back, approaching him again.>* You think those people who walk by you are smiling at you? You think they're being friendly, Michael? No Michael, they are *laughing*. People *laugh* at you. Because you are fifty years old, selling first grade arts and crafts on the street.

<Michael's twitching increases. W is now yelling.>

They pity you, sitting out there like a child, concentrating on rolling your green paper stems while I clean the *shit* out of old people's shitcans.

<W stays for a moment, her last words lingering between them, then storms out. Michael is now nearly convulsing, but trying unsuccessfully to conceal it by flipping through his color-coordinated papers.
Suddenly, the papers fall from his hands and scatter onto the floor. Michael drops to his knees to gather them. He is shaking so violently that, between his fingers, each paper rattles loudly.>

a hidden umbilical cord

the eager, young poppy
its abdomen sliced open
startles the drunken tyrant

he remembers a girl
clinging to his legs
her laughter raining green
upon the grass

<Stage left two men are fighting. They wrestle and punch one another
violently, each intent on causing the other injury.
As one man traps the other in a headlock, an enormous, brilliantly colored
bird falls suddenly out of the sky and lands directly before their feet. Upon
hitting the ground, a small snapping sound is heard. The two men freeze.
From the bird's mouth a thick stream of blood crawls out, spreading slowly
around its head, an uninvited halo. The standing man releases his grip as the
other withdraws. The stage is silent except for the heavy breathing of the two
men, which eventually dissolves into complete silence.
They stare at the beautiful corpse.>

Man 1: Do you think it's dead?

<long pause>

I heard something when it fell. Like maybe its neck snapped.

<longer pause>

Man 2: <quietly> Yeah, I heard that too.

<pause>

It's…bleeding.

<At the same time, both men look up. The sky is like a clear, blue breath.
They stare back down at the bird lying awkwardly at their feet.
Man 1 confusedly picks up his hat and, not knowing what else to do, walks
away, exiting stage right. Man 2 remains for a moment, then turns stage
left to exit. After taking a few steps, he stops, turns around as if to say
something, realizes there is no one to say it to, then turns back around and
walks offstage. Lights dim.>

toothpick fortress

<*It is an abnormally sweltering day. The sun unleashes her complaints in an inescapable bright heat.*
1, wiping her forehead with the back of her hand, sees a metal plate on the sidewalk. She recognizes it as her own.>

1: Who put this plate here?

2: I did.

1: Why?

2: I'm doing an experiment.

<*1 walks closer to plate, squints eyes, peers for a few moments, then, startled, grimaces in disgust.*>

1: What the hell? Have you lost your mind? What is that?

2: I said I'm doing an experiment.

1: Who are you, Frankenstein?
I'm getting nauseous. Go dump them out, in the grass <*Swallows. Still staring at plate.*> ...My God. Some of them are moving. Maybe they can still make it. <*Exhales.*>
I'm going to have to boil that plate, if we ever plan to use it again. Although, I don't know, I don't think I can ever bear to eat from it. I'll be convinced that even the finest dinner is just a plateful of earthworms, struggling to get out, their worm instincts flaring, fighting to survive...
We'll have to keep this set for guests. They're too expensive to throw away.

<*Pause. Neither one moves. 1 can't remove her eyes from the wild, pathetic display in the plate.*>

My God. You know this is sick right? I'm not even talking about the
fact that they're slimy, or that they dine on our eyeballs and genitals
when we die. I mean *you* are sick. You think mother nature's just
going to sit idly by and let you kick the small guys around like that?
Here you are with your brain, and your time, and your creativity, and…
and your insecurities, putting a pile of defenseless little worms under
the sun, at noon, on a scalding plate…in the middle of *August*. You
even had to search for them didn't you? They weren't even *in* your life,
they weren't interfering at all in your world.
What's wrong with you anyway? Did something happen at school?
<Turning to look at 2, with increasing concern.>
Look honey, we can deal with it, whatever it is. The pieces, inside,
that fall off and break sometimes, there are ways to fix that, I promise.
I know I'm not perfect, but I know my boundaries. I know who I need
to respect and that's that tree, that cloud, cause that's what we'll be
later. You see what I'm saying?

*<1 grows increasingly concerned about 2, and continues talking, wavering
between reprimanding and understanding.*
The worms in the plate have grown completely still.>

<The lights dim over 1 and young 2, and the lights go up over grown 2.
*He is seated on a cement block, wearing a construction hat, and his clothes
are dusty. He has been working overtime for three months now, and he is
visibly exhausted. He has been unable to sleep even in the few hours a night
between getting home and the alarm buzzing again like a knife in a bell.*
*He is just trying to live an honest life. There is a strange, uncomfortable
expression on his face. A group of men are standing around him, also
construction workers. They are laughing at something he has said. But 2,
looking away, is not laughing.>*

you assemble
for an audience,
fragment by fragment,
a smile, an awkward
rummaged nest,
to conceal confessions rubbed raw,
these perpetual baby birds.

you can still hear
the summon of a young leaf
searching for your waiting hand
in its descent,
and the steady tears
of the man who crushed
the green glass woman
in his embrace.

now smothered,
the foggy blossoming fingers
protest weakly
this whisper:
nights and days collide
clumsily, a barrel of abandoned marbles
each one like the next,
discarded and catching no light.

Marie wears flowers

god takes a bite
deep into evening's neck
and only the marks
and the beautiful loss
can be seen

marie wears flowers
that curl their stems
into a sleeping garden's imagination

they whisper
green
is the only language of the grass
close your eyes
for its brilliant howl
against rain's bludgeon

<Black smoke rises, dragging out its endless body. The clouds pass by,
ashamed of their freedom. They move tensely, avoiding each other's eyes.
They are guilty like the paper doll who ran away before the storm, and
returning, found everyone he loved dissolving in dark puddles, their limbs
and cheeks plastered around brick buildings.

It is noon. The bells chime an elaborate song. In a small, dark room,
someone is breathlessly pulling rope after rope.

On a porch, a large woman in a flowery housedress is seated on a bench
swing. In her hand there is a fan. Beside her, on a low table, there is a glass
of ice tea. Her lower lip is cut, and the left side of her face is bruised. The
clouds pass through her eyes. She is breathing weakly. From inside comes a
man's voice.>

Man: Marie? MARIE? Do you hear me? Dammit! <He steps up
to the screen door, completely naked, and dripping.> See what you've

done? Now I have to stand out here butt-ass naked. Where the hell is your brain at, if you've even got one. I've been calling you for hours. Where are the damn towels?

<She wants to speak, but she can't get herself to open her mouth. Her lips begin to tremble and a strange sound comes out.>

Man: What?

Marie: *<Licks her lips, frowning from the pain.>* It's on the bed. I laid it out for you when you got in the shower.

Man: Well---how the hell am I supposed to know that? *<Turns around and disappears in the house.>*

<The noontime bells have stopped dancing. Inside the house we hear doors slamming.>

Man: *<Angrily.>* Marie! Will you get in here a minute?

<She puts down the fan, and slowly rises from the bench. She walks to the front door, and stops. She does not move. She stands there, gazing at the doorknob. We hear the sound of drawers and cupboards slamming.

She pulls open the screen and steps inside, closing the door behind her.>

ghargh-e mina

who fed you
to this faucet dripping
over a waning violet,
all day dusk has been stealing
the lines from our moving bodies

despite fabled ruins
contusions
draw night's milk

I hear them,
cradles rubbing wearily together
their joints
so desperate to catch fire

<A woman stares vacantly at a baby crawling across a rug. Beside the
woman there is a piece of foil with a dark stain at its center and a lighter.
In the room there is no furniture. Rolled up against the wall is the bedding
the woman shares with her two children.
The baby stops to pick small things from the rug and places them in her soft
mouth. The woman does not shift her gaze, although it seems the gaze never
lands at all.
She sways a moment, subject to a phantom wind, then lowers herself to the
floor. She lies on her side, with her cheek pressed on an outstretched arm,
facing her daughter.
Noticing the change, the baby turns and crawls toward her mother, but,
receiving no response, begins to crawl away again.
The woman's eyes are barely open. Weakly, she calls out to her daughter,
but the baby is now seated, intently examining a piece of thread.>

Woman: <Murmurs, almost to herself.> I'm sorry, azizam. My
darling…you will forgive me I know…forgive me… <Laughs suddenly,
quietly, then stops, with a confused expression on her face. Closes her
eyes.> I'm sorry baby, maman had to…but later…<Her voice drifts off.
She opens her eyes again slowly. She speaks through a fog of sleep.>

I will give you a better life. You'll see. And guests will come, and we'll serve them sweets and fruits, and you'll wear clean white socks with white laces…

And you will go to school, and you'll have a colorful backpack, an American one or a German one…why shouldn't you…and you will laugh, all the time, you will be laughing…and I…I will laugh too…
<Her voice darkens.>

Just as soon as I close this wound. Just as soon as I extract their fingers and their noses and I sew it back up, we will be happy…<Tears begin to swell in her eyes. Suddenly, for a brief moment, it seems she is completely present.> I just wanted for us to be happy. Not just now.

Always. Always… I want more for you… <She closes her eyes again. A clouded smile passes through her lips, appearing and drifting away again formlessly. Her voice rolls out darker than before.>

That man has heavy, heavy hands. They are like anvils dropping on a landscape of eggs, some with unborn chicks inside, others with small suns, and he just drops them, not caring, not caring about what can't be undone… And you are so soft…and time keeps moving, away… and I can't return a single moment to you. Their remains litter this room and I can't breathe life back into them. I can't undo a single moment. Every, every moment, holes where laughter should have been, bruises where… <Her voice drifts.> And bedtime stories…you could be a doctor…at this moment…but look…that moment is already gone. And I can't hold it, or feed it. It's too fast, too far, and it carries you inside of it.

I'm sorry azizam, jigaram, forgive me, will you, forgive me…

<The baby crawls over to her mother and presses her face into her mother's breast. The woman, however, does not notice. She has sunk into a deep sleep. The baby sits back up, and places a small hand on her mother's ear, and tugs slightly, perhaps from curiosity, or to be fed, or perhaps simply as a silent declaration to be spoken to again.>

Miriam's song

<A song begins: a guitar and a piano approach and touch one another cautiously.>

Daughter: I dreamt it rained knives momma, and the blades cut gills into all our sleeping faces. We bled and bled until the whole world was only a dark ocean, and we each swam, in a daze, carrying our loneliness through the blood.

<Mother, on the bed, with track marks along her swelling arms. She has been dead for a few days.>

Daughter: Momma, remember when I asked you how those small drops of water hang from the faucet for so long without falling? I know why now. They use all their strength, momma. They use all of themselves.
No matter how small you are, if you use all of yourself, you can make it into the next moment.

<pause>

Momma? I'm afraid to sleep tonight. I don't want to swim all alone through that ocean again.

<pause>

Momma, will you sing me a lullaby?

inside a drop of water
a girl has grown a garden
she whispers to the flowers
they think she is the sun

beware of fear's seduction
each night is but a doorway
come, lay and listen closely
her song has just begun:

behind your tender eyelids
flow seven rainbow rivers
where mermaids rise to greet you
with pearls atop their tongues

I promise you an ocean
a boat of yellow roses
a wind that sways you slowly
until the night is done

a time to speak

homo sum: humani nil a me alienum puto
Terentius

this is no place for secret hooks.
the tiger lily launches
at every passerby
her most intimate and imperfect parts,
for she knows no other way
to live.

<It is early evening. An old man is seated on a park bench, smiling as if
through a fog.
A teenage boy comes running loudly in from stage left, a flailing kind of run,
marked with exhaustion and fear. He is clutching a woman's purse and just
before arriving at the bench, he slows to a stop and bends over with his hands
on his thighs. He is loudly panting.
After a moment, he rises, and turns to look over his shoulder. Seeing
nothing, he relaxes slightly, then goes to the bench and sits down. He sits as
far as possible from the old man. His movements are marked with tension
and a muted anger.
Turning slightly away from the old man, the boy opens the purse and begins
rummaging through it when the old man turns to him and broadens his soft
smile. The boy abruptly closes the purse and with great irritation turns to the
old man.>

Boy: What the hell are you staring at?

Old man: <kindly> Are you ready?

<pause>

Boy: <with great irritation> What?

Old man: The train will be here any minute. Are you ready?

<The boy stares at him for a moment, then emits a loud echo of a laugh.>

Boy: <his mocking tone grows more aggressive as he speaks> Oh, yes, the train. Uh huh. Yeah, I hear it already. It's coming right now. Uh oh, hurry up, you better hurry up or else you're going to miss it.
<He pushes the old man roughly, as if urging him to get on the train. The old man looks terribly confused.>

Boy: <jumping up> Oh shit! Now look what you've done! You missed the damn train. It's gone now and it'll never come back. It'll never ever come back again. The train is gone, and you missed it.

<The old man does not say a word. The boy, getting no reaction, stares at the old man for a while, then sits back down to examine the contents of the purse.>

Old man: <still a little confused, but regaining purpose as he speaks> The train will be here at 1:15. I told your mother to come say goodbye, but she thought she might cry too much, so she'll just see you at the end of the summer. But she promised to write you letters. Okay? She promised to write. So please don't cry.

<The boy, now certain that the old man is harmless, is rummaging through the purse. He throws out some things, stuffs other things in his pockets. When he finds lipstick, he tries to force the old man to take it. When the old man doesn't respond, the boy pulls the lid off and reaches over, painting the old man's lips with it. The old man, part of his lips and chin now marked clumsily with red, turns away, and the boy, not laughing this time, throws the lipstick out into the grass, then begins digging again through the bag.>

Old man: <quietly> I don't wear lipstick…

<The boy, not listening, is counting cash.>

Old man: <quietly> You know I love you, right? I love you very much.

<The boy suddenly looks at the old man. The boy has never been told that he is loved.>

Boy: Are you fucking crazy? Actually yes, yes, what am I talking about? Of course you're fucking crazy. <He leans in toward the old man.> Let me give you some advice. Next time you're sitting on a bench with another man, don't tell him you love him, because you might get your throat sliced open, you fucking fag.

<The old man's face again appears confused, then precipitates into a wrinkled sorrow.>

Old man: <his eyebrows furrowed, staring deeply at the boy> Please don't be angry. I didn't know. I had no idea what was going to happen. Please, please don't tell your mother, just give me a little bit of time. I'll tell her what happened, but I just need some time. Okay? Promise me, promise me you won't say anything.

<The boy is looking at the old man with a look of suspicion, trying to maintain an emotional distance.>

Old man: I didn't know what would happen. I drove there, I drove there looking for you, as soon as I found out. And people were screaming and melting all at the same time...
<smiling> But I found you, didn't I? I found you, and I pulled you out, and I held you, I held you until they pulled you from my arms. So... so let's not tell your mother yet, okay, it'll be our little secret for now. I don't think, I know, I know she can't bear it. <The old man puts his hand on the boy's arm. This pulls the boy out of his stillness, and he roughly shakes off the old man's hand, and rises. Stuffing the cash into his pocket, he turns to leave, then stops, and stands still for a moment. The scene is still. He turns to the old man and asks him for his coat.>

Boy: It'll be cold on the train.

<The old man, smiling again, slowly takes off his coat, and folding it carefully, extends it toward the boy. As soon as the old man begins to remove his coat, we see that his arms have been severely burned, with protruding scars that crawl up toward his neck.
The boy suddenly looks afraid. He stares at the man's arms for a long time. He turns around abruptly with the intention of leaving, but does not take a step. He stares down at his feet.
The old man has placed the coat in his lap, still smiling, but with great sadness in his eyes.>

Old man: The train is coming.

<silence>

<The boy turns to the old man, but doesn't look at him. One of his hands is clutched in a tight fist. There is a long pause.>

Boy: Dad *<his voice cracks slightly; he looks directly at the old man>* I forgive you.

<The boy quickly turns and walks away.>

bus stop

every miracle
possesses an agony

all day
I have been squandering miracles
striding lethargic and barefooted
across their heads
a field of yellow chicks
crushed quietly underfoot

all the while
against a ravenous solitude
a girl is murmuring
the secrets of our alchemy
counting them
like prayerbeads in the dark

<a young girl wearing an enormous backpack is seated at a bus stop bench.
her legs do not reach the ground and her sneakers have holes in the toes.
her hair is in a low disheveled ponytail and contains fragments of twigs and
leaves.
a boy approaches the bench. he is about the same age, also wearing a
backpack, but his appearance is very different. it is evident he is well cared
for.
the boy does not sit down, but instead stands at the other end of the bench.
a pigeon lands on the sidewalk and begins to peck around. neither of the
children look at one another. after a moment, the girl turns, pretending to
look at something. hunching slightly forward, she pulls her sleeve over her
hand and roughly wipes around her mouth.
a gentle swell of water rises to the cusp of her eyes. still looking away, she
lowers her hand.
the boy pretends to look at his shoes. more pigeons land.
one of the pigeons, a newcomer and much bigger than the rest, bullies the
others, taking their food and chasing some to the outskirts of the gathering.
the children turn to watch this interaction. the weakest birds linger furthest

from the food, waiting for crumbs flung from the bigger birds.
the girl takes off her backpack and pulls it around to her lap. the boy
watches her out of the corner of his eye. she pulls out a small paper bag,
then, leaning forward, she places the backpack behind her and puts her arms
through it as before. from the crumpled bag she takes out some half eaten
food. making crumbs with her fingers, she disperses them near the smaller,
skinnier birds.
after a few moments, a bus arrives and the birds abruptly scatter. the girl is
still holding the bag in one hand and the crumbs in the other. the bus door
opens. the boy hesitates. still, neither child turns to the other. the boy
approaches the bus door, his movements slightly awkward and tense. as he is
about to step on the bus, he turns to the girl.>

boy: good bye.

<he climbs on the bus, and as the girl looks up, the door closes and the bus
drives off. the girl watches where the boy was standing, even after the street
is empty.>

fallen stars

chest-first she leapt from the cliff-edge
a girl in the sun
the rapture
of holding a word
to the light.

oh the blood colored gills
of one unyielding feeling
beating its body
against the bottom of a boat.

<In a room, a woman is sewing fallen stars to her hands. A little girl walks in.>

G: What are you doing?

W: I don't know. <She begins to cry, trying to shake the star-skins from her hands, but they do not fall. They are interwoven. The little girl walks over to her.>

G: <Petting her leg:> It's okay. They're not really dead, they're just sleeping.

<The woman stops shaking her hands; she looks at the celestial remains. The stars are completely dark, not a flicker or a dim exhale among them. She raises her hands, placing them near the lamp beside her. Some of the fallen stars catch the lamp light, like fragments of glass. The woman smiles. The girl smiles and pats the woman's leg.>

G: See, they were just dreaming. Everybody needs to close their eyes sometimes.

<The woman kisses the girl on the cheek, then rises and leaves the room.>

gift

in this mere exhale of light,
the radiator aching its heat,
sirens hysterical and bleeding in their cages,
I have drowned my heart a hundred times,
luring it like a coward
away from its revelations

the view from the threshold,
windless,
wears no bells

<An old man in a hospital bed. His hardened belly pushes a smooth white
hill into the sheet. A young woman walks in, closing the door behind her.>

Young Woman: <Visibly uncomfortable.> Hi.

Old Man: Hello. <Smiles.> Is your mother here?

Young Woman: Yeah, she's outside. I just…wanted to come in alone.
I hope you don't mind.

<The sound of coughing in another room, then silence.>

<With great feeling.> I've missed you.

<She walks to the side of the bed. Uneasy standing over him this way, she
moves to a chair and sits.>

Old Man: I'm dying.

<Silence.>

I didn't want you to me see me like this.

Young Woman: I know. But I wanted to see you.

Old Man: Why haven't you called?

Young Woman: I did, a while back, and I left a message, but you never called back.

Old Man: So why didn't you call again?

<The young woman doesn't know what to say.>

<More lightly.> What have you been up to? You're still writing, I hear. Did you bring any of your work with you?

Young Woman: No. But I'll leave a book before I leave.

Old Man: You've written a book?

Young Woman: Yes. I mailed one to you.

Old Man: I never got it.

Young Woman: Really? Oh. Well, I suppose that's a relief; I was hurt you hadn't said anything about it.

Old Man: No. I never got it.

<pause>

Are you finished with school?

Young Woman: Yes, it's been a few years now.

<The sound of muffled beeping.
The woman fights an urge to fill the silence with meaningless things.>

Old Man: You know, my children hate me.

<The young woman opens her mouth to say something, but changes her mind.>

Have you ever met my children?

Young Woman: One of them, yes, when I was younger. *<She leans toward him, speaking hesitantly.>* We all have things we need to be forgiven for.

<She says this in a very heartfelt way, her face exposing the emotion of her statement.>

Old Man: I'm getting sleepy.

Young Woman: Oh, sorry. *<She rises, a sudden fist swelling behind her ribs.>* Is there anything I can get you before I leave?

<pause>

<The old man's eyes are closed. He could be thinking, or perhaps he is already asleep. The young woman closes her eyes too, for just a moment, to fight the steel plague creeping its spread across her chest. Hospital rooms can't help but make one feel like a stranger, she thinks. It is their curse, the way they're used over and over by uncommitted hearts longing for home.>

Old Man: Will you kiss me? On the lips?

<The young woman opens her eyes. The old man is not looking at her. She doesn't know it yet, but her body is trembling. She moves slowly to the bed and takes his stubbly, old cheeks between her hands. Her throat fills with tumorous knots, but the rest of her dissolves into the thin hospital air. She presses her lips against his and holds them there for a moment. Pulling away slowly, she tells him "I love you", then walks toward the door to leave.>

a pigeon story

forgive the undiscerning sun
her equal embrace
of feces and daffodil

even now, with this blood-stained
bassinet
the river undulates
in a diamond studded dress
her thousand, succulent hips
for the fishermen and young boys

even silence
hunchbacked and slurping
from these unguarded wounds
is someone's daughter

<A low cacophony of pigeon sounds. Three men on a rooftop. Man 1
stands beside a pigeon coop, holding a bird. Man 3 holds Man 2 on the
ground.>

1: <Squeezing a pigeon in one hand.> What's this one's name?

2: <Whispering.> Dina.

<1 presses a razorblade into the bird's chest and drags it down the feathered
bulge. He squeezes the bird as he slices it, the blood gathering between his
fingers. Then he uncurls his hand and drops the pigeon into the growing pile
at his feet.
He reaches into the coop and grabs another.>

1: <Gripping the bird between his fingers.> And this one?

<2 does not respond. With a fistful of hair, 3 shakes 2's head.>

3: What are you, deaf? He said what's the name of the bird.

<2 remains silent.
His mouth glistens, wet, candy apple red. He has tried before to refuse. But
this time, he remains silent.

The day is glaringly bright. The river must look stunning from the rooftop.

This time, 1 doesn't repeat himself. The temperature has been steadily
increasing, and the odor from the paste on his hands has begun to make
him nauseous. He pushes the blade into the bird, squeezes it, and drops
it. At his feet, the bird imperceptibly moves its wing. 1 grabs another, and
continues slicing, squeezing, dropping, slicing, squeezing, dropping.

All the while, 2 hears their names. Just thought whispers now, not really
apologies or goodbyes. Just registering, identifying. The keepers of his
secrets, discarded like so many banana peels.

3, still holding 2's hair in his fist, chews loudly his gum. His eyes wander to
the slow procession of clouds, all moving patiently to the same destination. If
he stares at them long enough, he gets a strange feeling in his stomach, like
he's flying.

With his free hand, 3 wipes his brow.
From somewhere in the pile, a pigeon is making a sound.
And then, in the weightless and uninterrupted flow of daylight, in very
unceremonious terms, it's over.
There is, of course, a final kick, and a collapse. Another, heavier,
discarding. Footsteps. An onslaught of sunlight. Silence.
2 is left lying on his side, near the pile of birds. His candy apple red,
achingly slow, crawls toward their pomegranate paste, their collective,
bewildered halo. The peripheries of their secrets nearly meeting.>

looking box

Along the subway pillar
I once loved
the rusted face of a burned woman
slowly smothered
beneath the weight of her hair,
oh melancholy orange cloudshape
so nearly unseen.

Despite the gray choke
of a varicose afternoon
a bird is calling.

<A man looking through a hole into a box. Apart from a scarecrow in the distance, there is nothing around him. A second man appears. He stands for a minute, waiting his turn, but the first man doesn't show any response to his presence. After a moment, the second man clears his throat.>

2: *<Clearing throat.>*

<1 doesn't move.>

2: Excuse me, may I look?

1: Just a minute.

2: *<Happy to have gotten a response.>* No problem. I can wait.

<2 waits. 1 doesn't move. 2 is still smiling, but growing restless. 2 looks around, shifts to one foot, later, to another.>

2: *<Clearing throat again. Not looking directly at 1.>* Actually, I have an appointment to catch…I'm actually running quite late.

1: With who?

2: <Caught off guard.> I'm sorry?

1: <Finally standing up, turning to face 2.> I said who's your appointment with? <As he says this, he takes the box in both hands and throws it on the ground, then smashes it under his feet.> I'm asking because I thought we could walk that way together.

<2 is completely stricken. He stands looking at the broken pieces at their feet.>

2: Why did you do that?

1: <Very casually, almost friendly.> Do what?

2: <Increasingly desperate.> You knew it was my turn. I even asked you. I asked you if I could look inside. And, you told me to wait. Why the hell did you tell me to wait?

1: <Still casually.> I don't get it.

2: <Infuriated now, fighting a swell of tears.> Why did you smash the looking box when you knew I wanted to look in it?

1: Oh, it wasn't very interesting.

2: <Yelling.> But I wanted to see it for myself!

1: <Grabs 2's collar, talking through his teeth.> I said, it wasn't very interesting.

<1 stares at 2, then releases his collar. He then looks down at his pants and begins to pat them off, as if wiping away dust.>

1: <Casually.> So, which way is your appointment?

2: <Looks very small. After a short pause.> What was inside?

1: <*Exhales. Pause.*> A scarecrow.

<*2 is devastated. He wanted so much to see the scarecrow. In the distance, a flock of birds flies over the stuffed man. 2 lets himself fall to his knees like a small child. He is mumbling under his breath.*>

1: <*Confidently.*> Alright, well, I have an appointment.

<*He walks off. 2 does not get up. Tears stream silently down his face. In the distance, the scarecrow is in love with the birds. He feels the breeze of their flight but cannot raise his face to see them.*>

bedtime story

abruptly
is no doorclap
in the wind

it is the violent simplicity
of too late
and the unsaid
indigo declarations
bludgeoning your heart from the inside
trying to escape

how steadily loss
forces anvils down the throat
of silence, daring us
to sing

<Two children lying down in the dark. The boy, younger, rests his head on the girl's shoulder.>

Boy: <Teeth chattering. Shivering.> I'm so cold.

Girl: <Shivering.> I know, I'm cold too. Just try to sleep.

Boy: I can't. It's too cold. And it's too dark.

Girl: Use my body for warmth.

Boy: Your body's freezing.

Girl: Okay, well, please stop complaining.
They'll be here soon. If you go to sleep now, then you won't have to wait. You can just close your eyes and when you open them, they'll be here.

Boy: Where's my toy?

Girl: I don't know. You must have left it behind.

<Boy starts whimpering.>

Boy: No.

Girl: No what?

Boy: I *didn't* leave it.

Girl: Ok. You didn't leave it. Either way, it's not here now.

Boy: <Whimpering more loudly.> I want my toy...

Girl: Stop crying. There's nothing we can do about it now.

<Boy crying.>

You should have been more careful. I can't keep track of all your things.

<Darkness. More crying.>

Girl: <After a moment.> You want me to tell you a bedtime story?

<Boy nods his head, sniffling.>

Girl: Ok. But you have to close your eyes.

<Boy, still shivering, closes his eyes.>

Girl: Once upon a time, there was a great warrior who lived in a castle with the king. The warrior won every battle he fought, and traveled to many faraway kingdoms. But the warrior was not happy. One

day, while he was riding his horse into the forest, he heard a strange sound…

<Sound of footsteps. She stops.>

Girl: Did you hear that?

<Boy has already fallen asleep.>

Girl: It's them. I told you they'd be here soon.

<More footsteps. Silence.
Lights go up. We see a man in a white lab coat. Beside him stand a man and a woman. Beside them, a steel wall covered with little square doors. The man in the lab coat opens one of the doors and pulls out a long drawer. A rush of cold air emerges. Inside the drawer lie a young girl and an even younger boy. The boy's head is tilted toward the girl's shoulder.
As soon as the drawer is pulled out, the woman collapses. The men try to help her up. She screams, beating her thighs with her fists. Her voice, unable to permeate the frigid tiles, spreads and collides with itself in the room. A flock of stunned birds flying hysterically into the walls, into each other.
The men stand her up. She is trembling violently. She goes to the children, shakes them, screaming their names. She covers their faces with kisses. She promises them things.
When she begins to claw at her face, the two men try to restrain her. She fights them, trying to grab the children. Finally, after some struggle, they escort her out of the room.

The room is empty. The drawer still pulled out.

The man in the white coat returns.
He takes a few steps, then stops. He presses his knuckles into his eyes and begins to sob.

Permanence, filing its nails, stares at him coolly from the corner of the room.

From somewhere down the hall, we hear a loud moaning: "…my babies… my babies …".

The man walks over to the children. With his hands, he gently brushes the hair from their faces. He kisses each one on the forehead, and whispers, "You're going home. You're going home.">

about the author

Shabnam Piryaei was born in Iran and raised in the U.S. Her work has been published in several journals including The Florida Review, Runes: A Review of Poetry, Flashquake, and The Furnace Review. She has been awarded the *Poets & Writers* Amy Award for poetry, as well as an Elizabeth George Foundation grant. Currently she is developing three short films based on her writings.

Breinigsville, PA USA
20 January 2011
253714BV00001B/5/P